Color Book Crazy

Horses

Volume 1

Author: VL Manlick

Copyright © 2016 One Tiger, LLC and VL Manlick
All Rights Reserved

Published by Create Space

About the Author:

This is the first Adult Coloring Book that I am publishing. I enjoy the process of making unique designs for the books. Parts of my designs you may have seen in different Coloring Books, worked into one of my designs. I have a different style as all Graphic Designers do. I really don't call myself an artist, but a Graphic Designer, well maybe an artistic graphic designer.

I really enjoy the design process, I will look at an image and some times I can visualize a completed design, many times I will start a design with a visualization and then it becomes something totally different than where I thought it would go when I started.

My background is diverse as I get bored when I don't have a creative outlet. This gives me the opportunity to create different themes of books and use my creative side. I have a few years of experience with Pre-Press work so that works very well here. I have so many ideas spinning around in my head for different themes of books.

I have a tendency to think out of the box so to speak so my designs are possibly a bit different than what you normally see.

I hope you enjoy my work. I enjoy horses I use to have two, and I could sit and watch them for hours every day. Horses are truly magnificent animals.

VL Manlick

Introduction:

This is the first volume of Color Book Crazy Horses. I will be publishing additional books with horses, as I really enjoy horses and have in the past owned horses.

In this volume some of the designs are intricate and detailed and other designs are more simple. Some times I enjoy just coloring a bit more simple design. I have seen some of my friends post pages they are working on and I admire the author and the person coloring the pages, but I couldn't work on them because this is my relaxation and those designs would try my patience, so that would not be very relaxing.

In this Volume I have taken one design and done three different versions of that design, as I was working with the design I thought well how would it look if I did this and I liked it, then I thought what would happen if I did that and I liked it also, so I included the three versions in the book.

As I have been making designs I have spent many an evening coloring them. Some of my designs I have changed and one will never be printed because I didn't like it at all once it was colored.

I will be posting some of my colored designs on the website ColorBookCrazy.com. If you are stuck and just not sure on what colors or what it might look like when you are done feel free to check out the examples. Remember this is not a Color By Numbers book, so use what ever colors or medium you want to work with.

Have Fun and Color On.

Index:

About Author	Page 2
Introduction	Page 2
Index	Page 3
Alister with Halter	Page 5
Abstract Horse Head on Mandalas	Page 7
Sally on Mandalas Background	Page 9
Double Love	Page 11
Abstract Horse Head on Mandalas	Page 13
Duke The Gentle Giant	Page 15
Pegasus	Page 17
Gina Version 1	Page 19
Gina Version 2	Page 21
Gina Version 3	Page 23
Sid Star	Page 25
Sassy Sam	Page 27
Wild Hair Day	Page 29
Four Horses	Page 31
Tony Abstract Horse	Page 33
Dolly	Page 35
Lulu Bell	Page 37
Shasta	Page 39
Sid and Sidney Star	Page 41
Bonnie the Bowing Horse	Page 43
Abstract Bob	Page 45
Abstract Slim	Page 47
Unicorn	Page 49
Justine	Page 51
Rudy Abstract Horse	Page 53
Honey on Six Hearts	Page 55
Butch waiting for his cowboy	Page 57
Justine on Flower Background	Page 59
Old English Hunting Photo	Page 61
The Start Family	Page 63
Striker the Stallion	Page 65

Intentionally Blank Pages
4, 6, 8, 10, 12, 14, 16, 18, 20, 22, 24. 26, 28, 30, 32, 34, 36
38, 40, 42, 44, 46, 48, 50, 52, 54, 56, 58, 60, 62, 64 and 66.

This page is intentionally blank

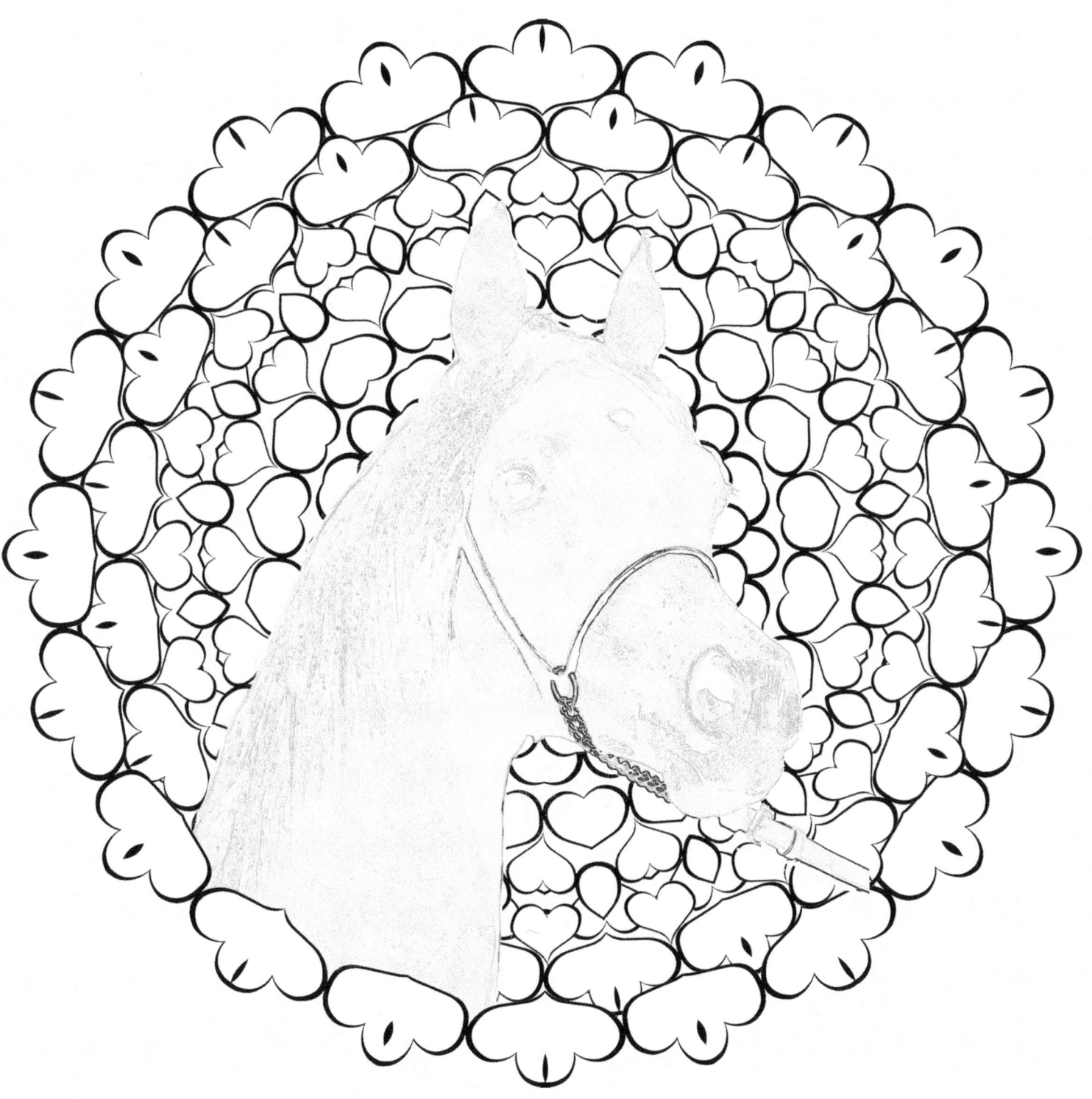

Alister with Halter

This page is intentionally blank.

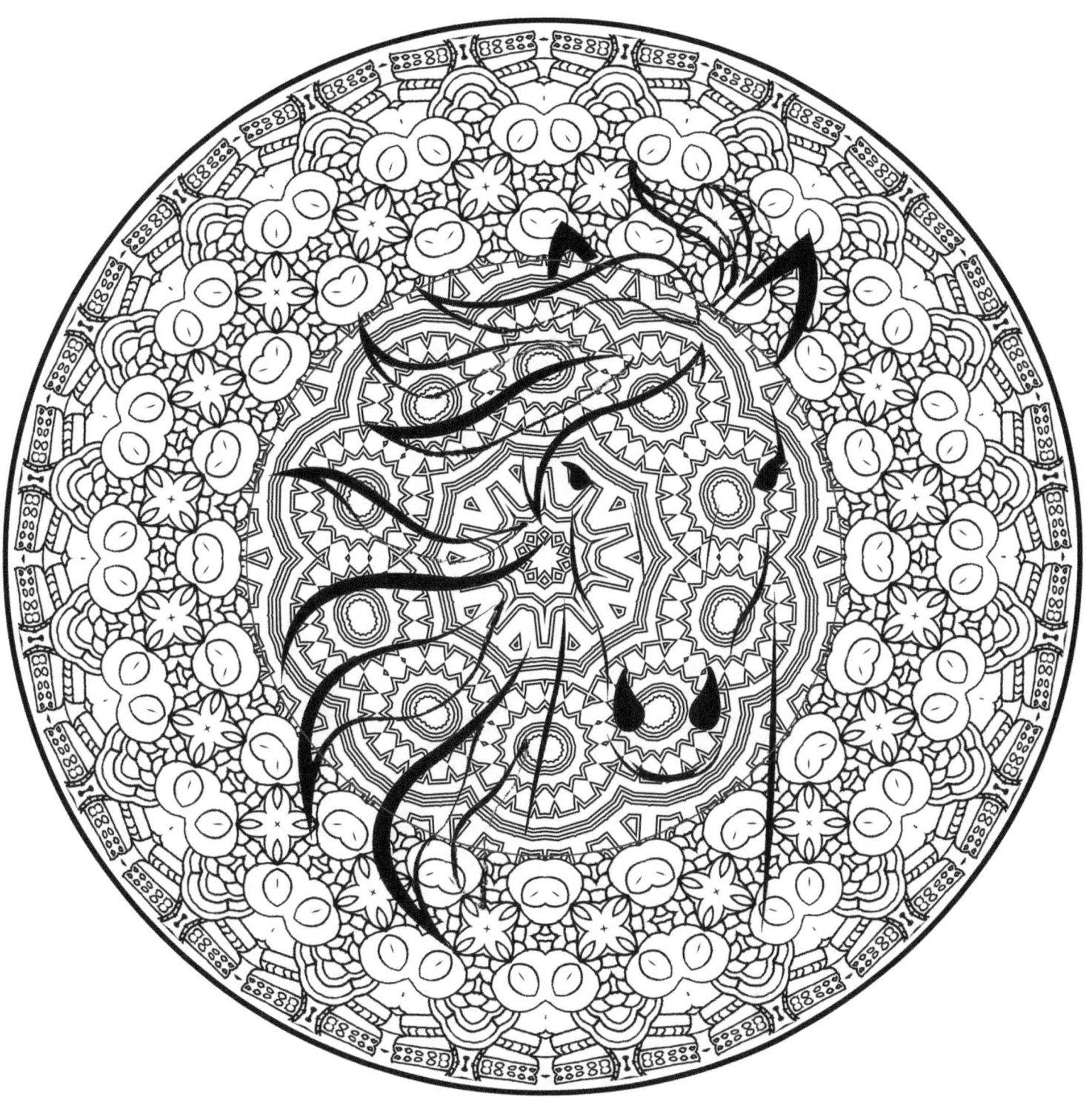

Abstract Horse Head on Mandalas

This page is intentionally blank.

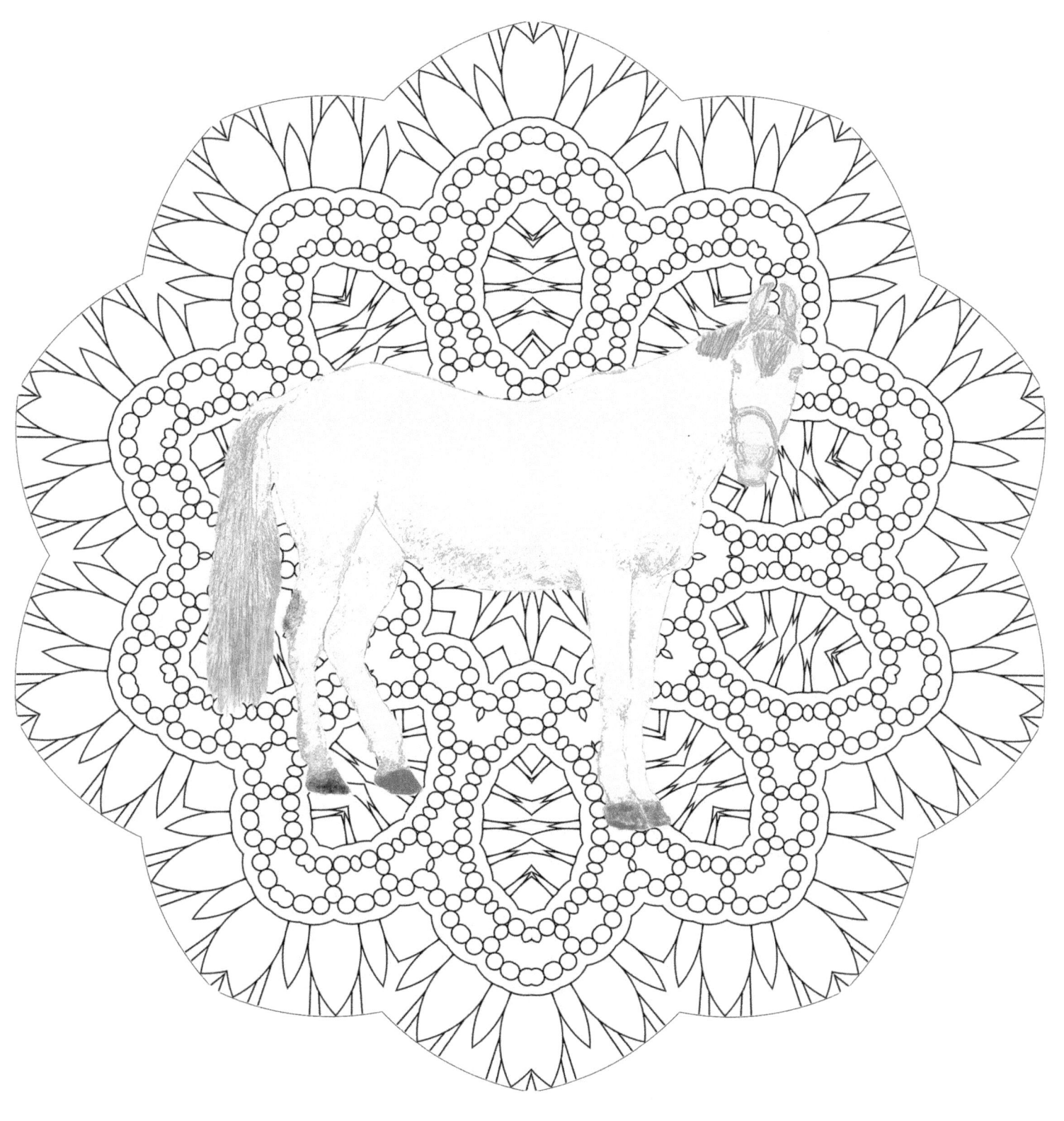

Sally on Mandalas Background

This page is intentionally blank.

Double Love

This page is intentionally blank.

Abstract Horse Head on Mandalas

13

This page is intentionally blank.

Duke the Gentle Giant

This page is intentionally blank.

Pegasus

This page is intentionally blank.

Note from the Author:
The next 3 images (Pages 21, 23 and 25 are the same base image with different parts of the Image inverted. I made the first image and then my mind went to what if this part was Inverted, then what if the other part was inverted. So you have 3 pages with basically the same image, but when you color them they will look totally different. Have fun.

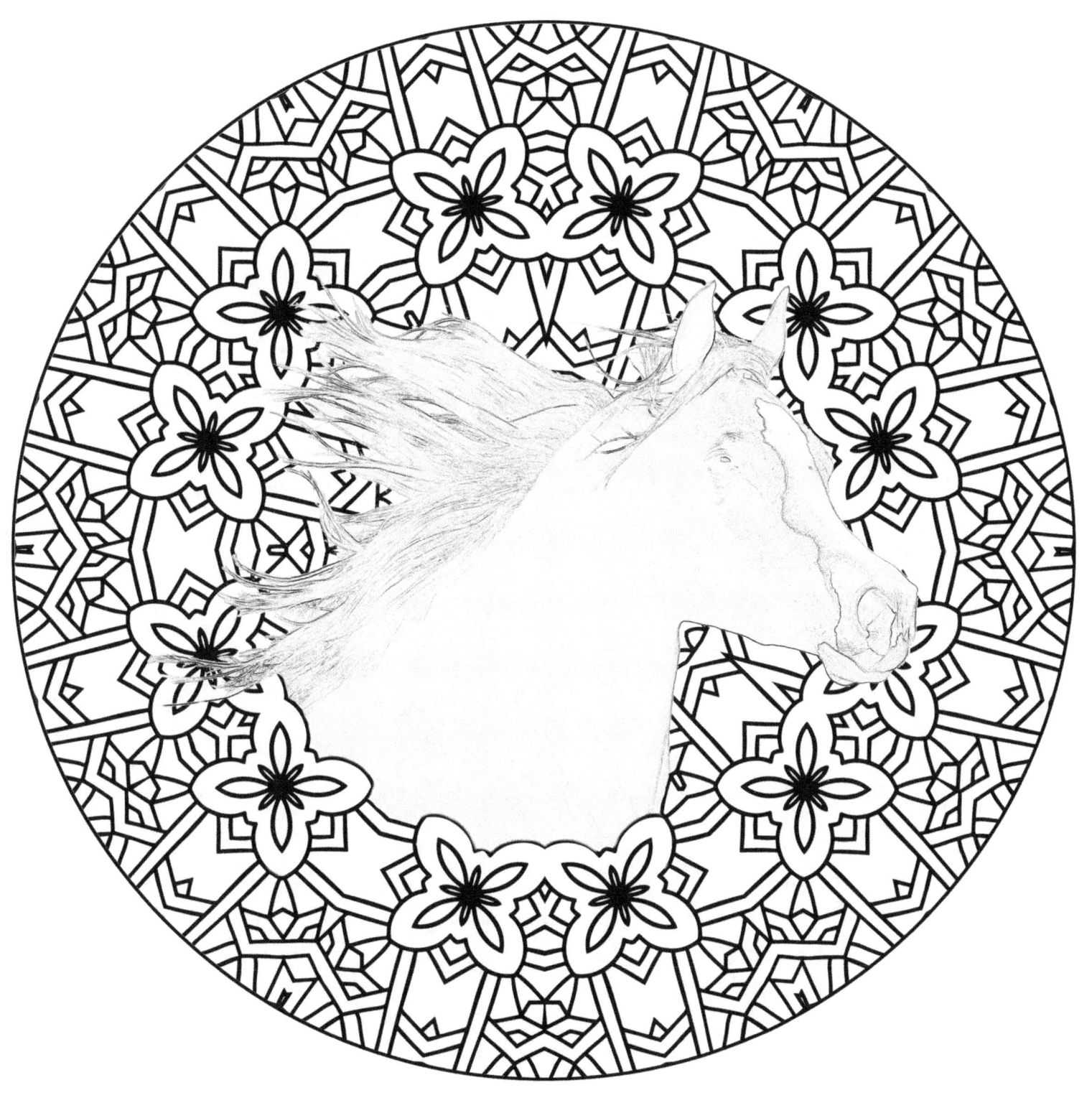

This page is intentionally blank.

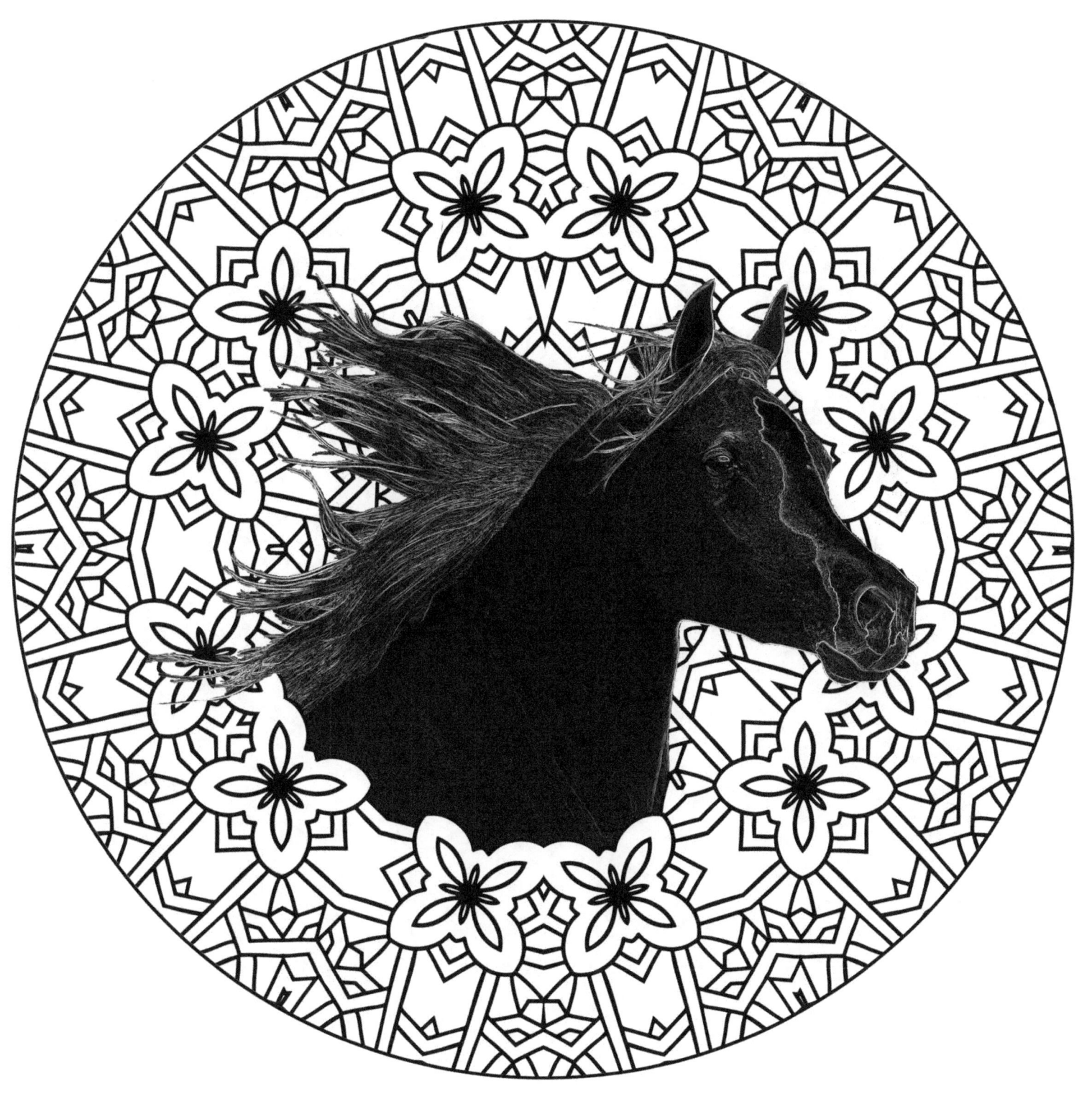

This page is intentionally blank.

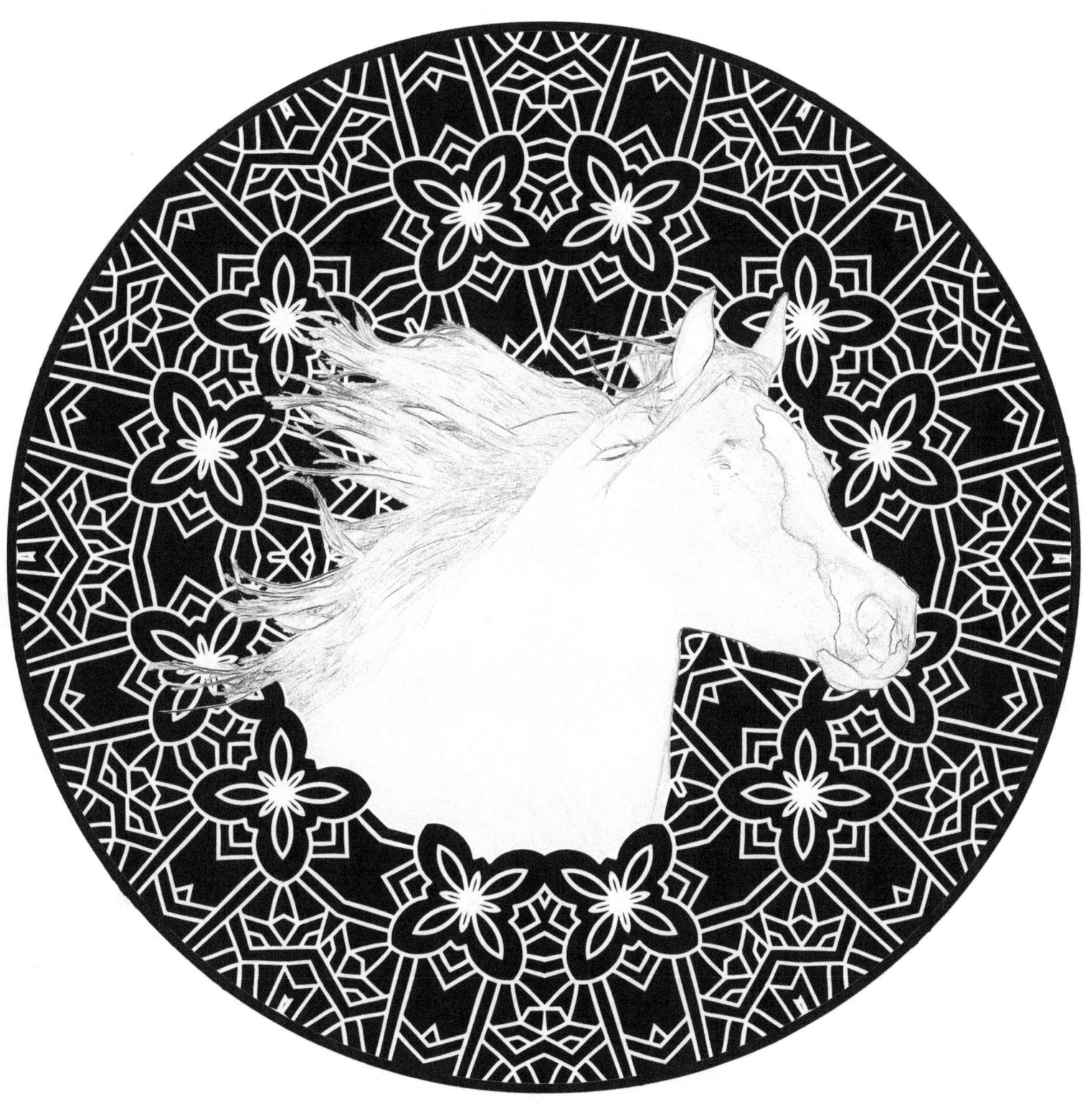
Gina Version 3

This page is intentionally blank.

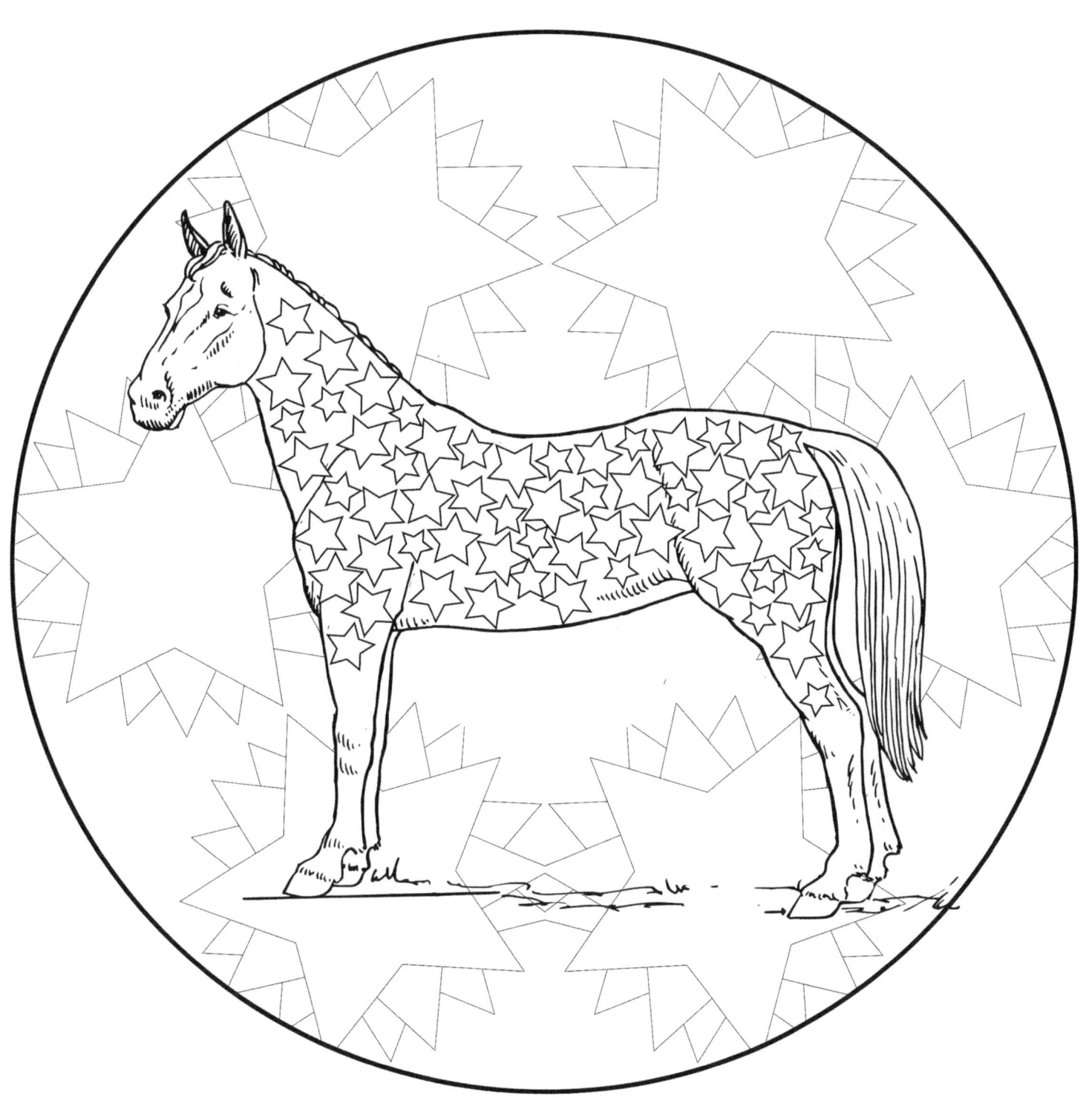

Sid Star

This page is intentionally blank.

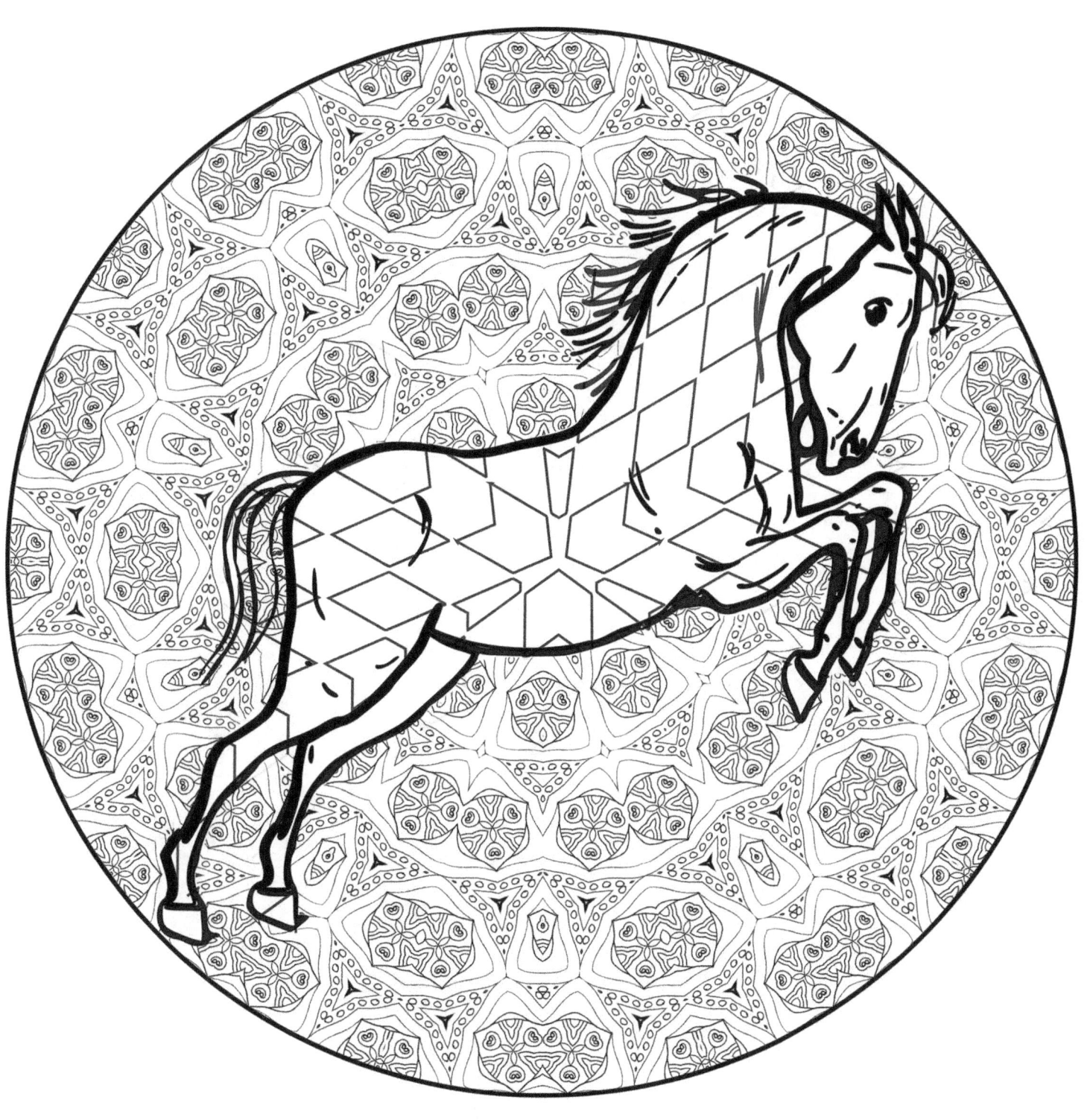

Sassy Sam

This page is intentionally blank.

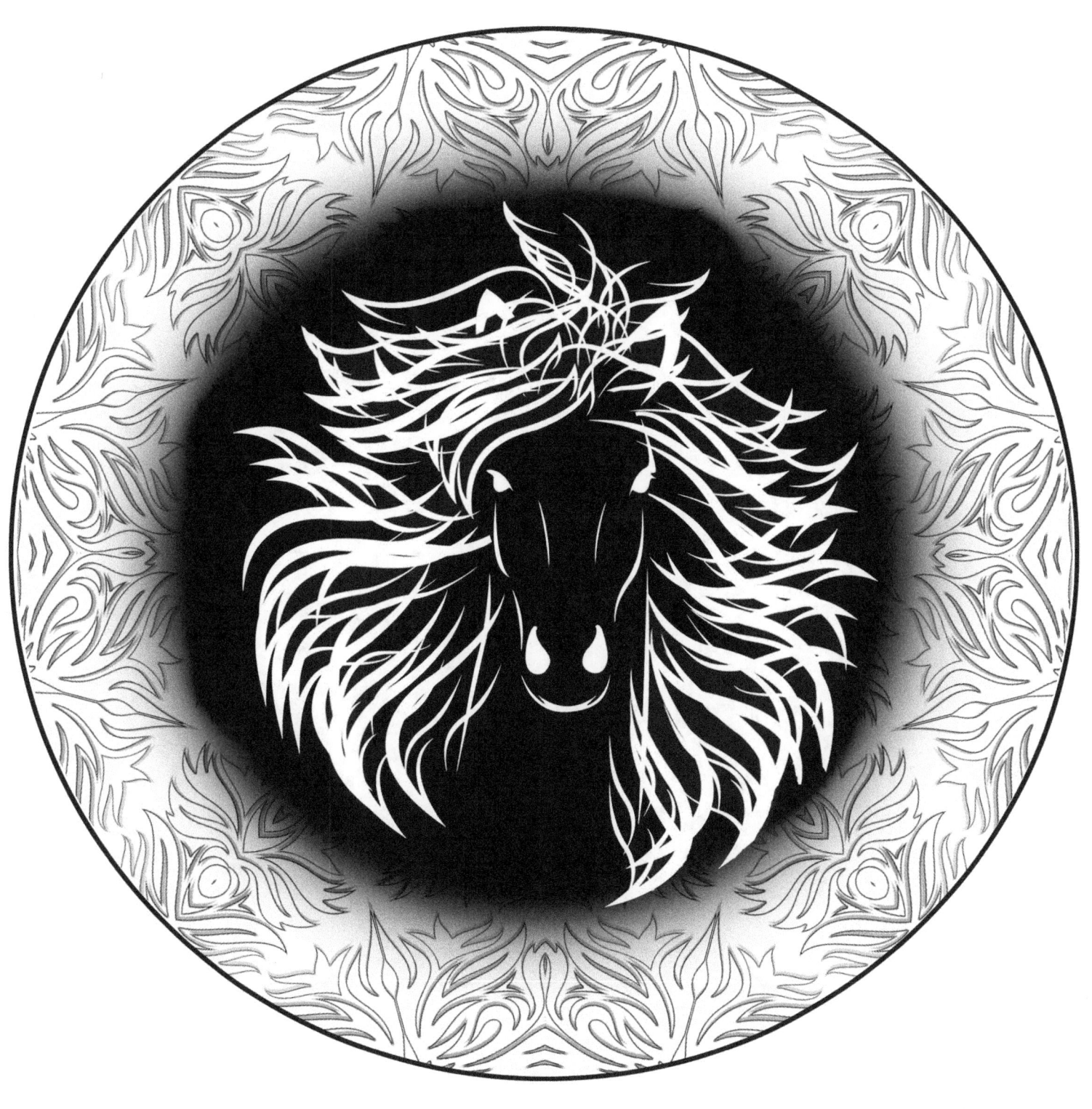

Abstract Horse with a Wild Hair Day

This page is intentionally blank.

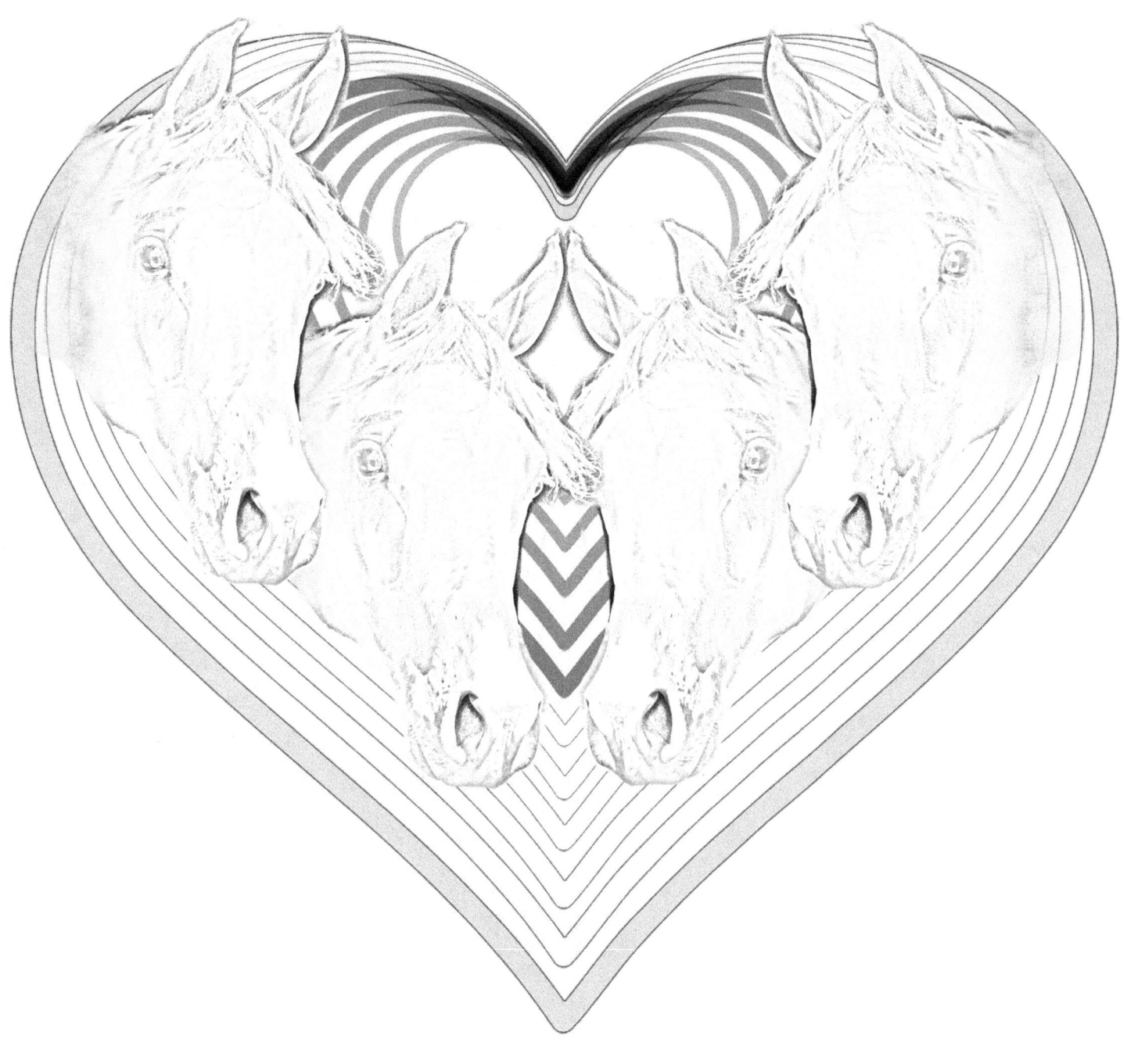

Four Horses

This page is intentionally blank.

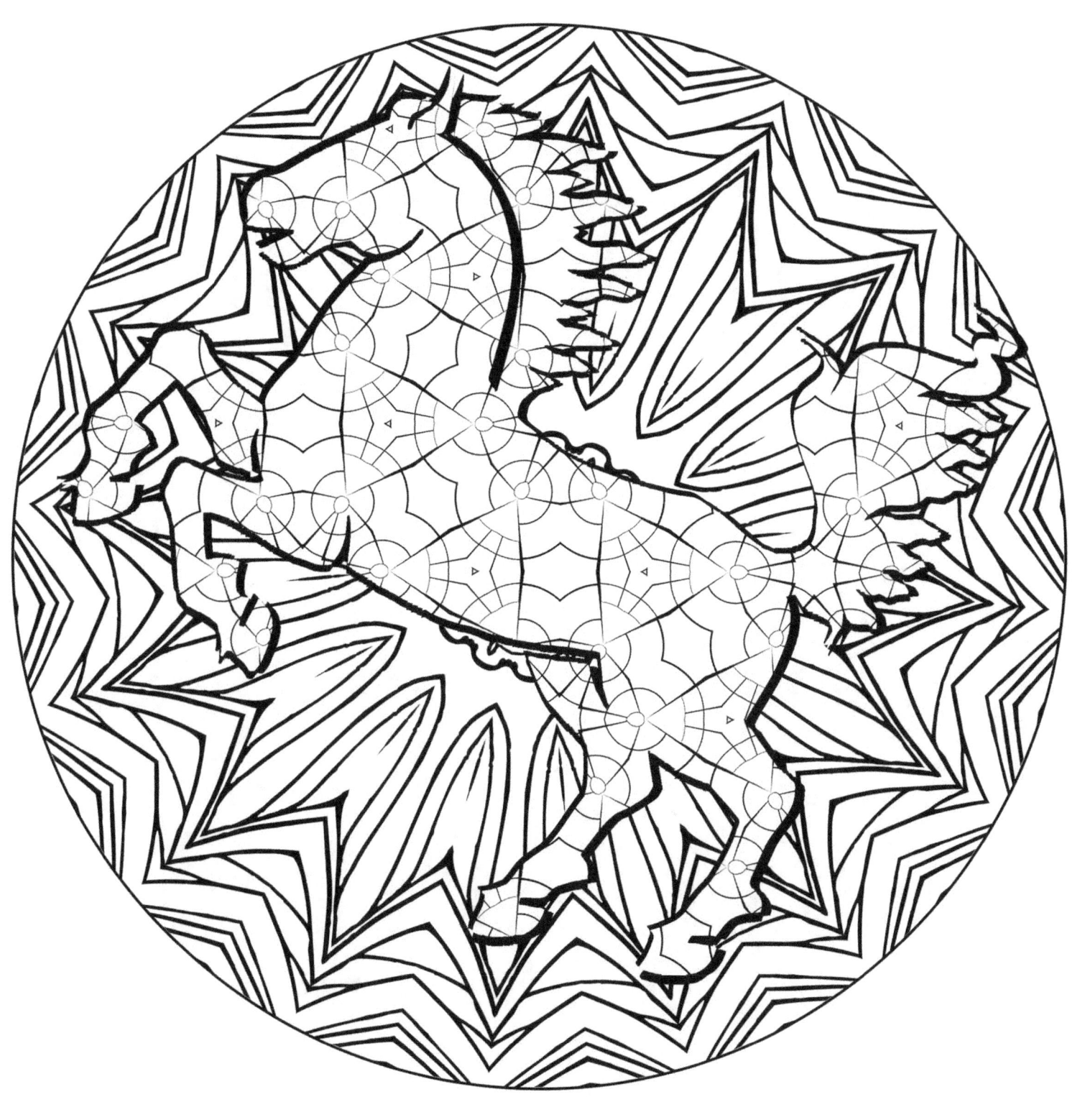

Tony Abstract Horse

This page is intentionally blank.

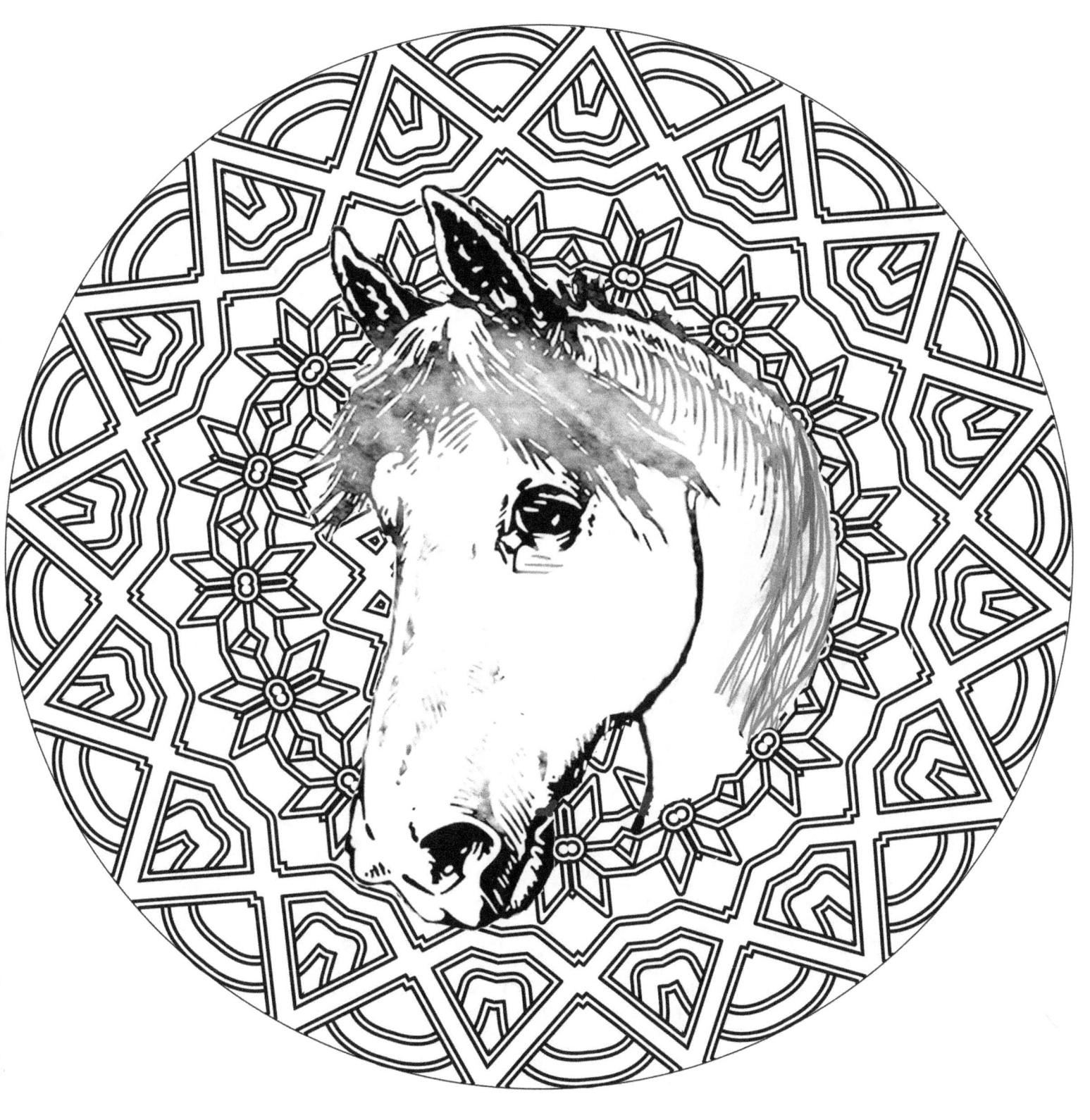

Dolly

This page is intentionally blank.

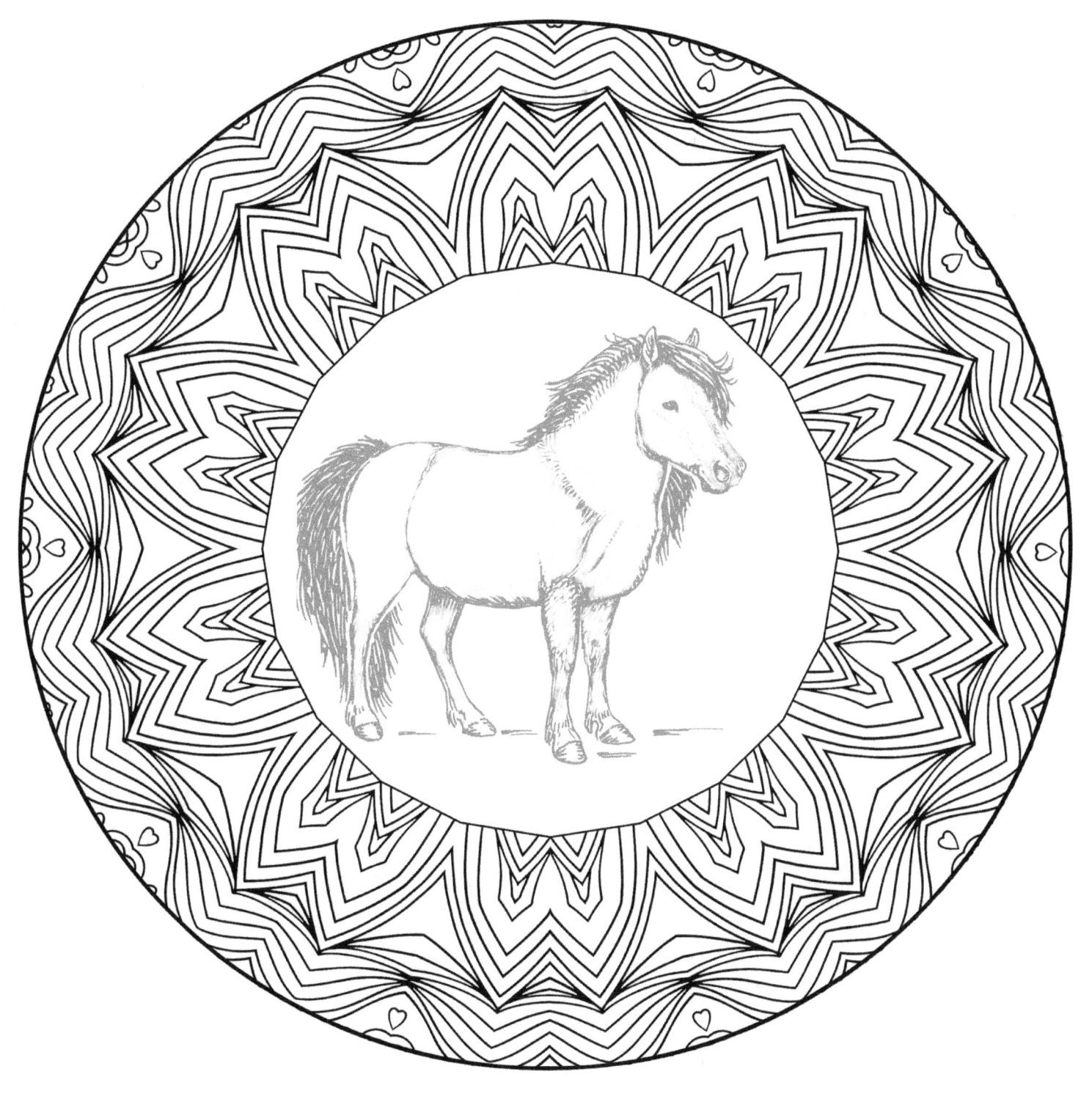

Lulu Bell

This page is intentionally blank.

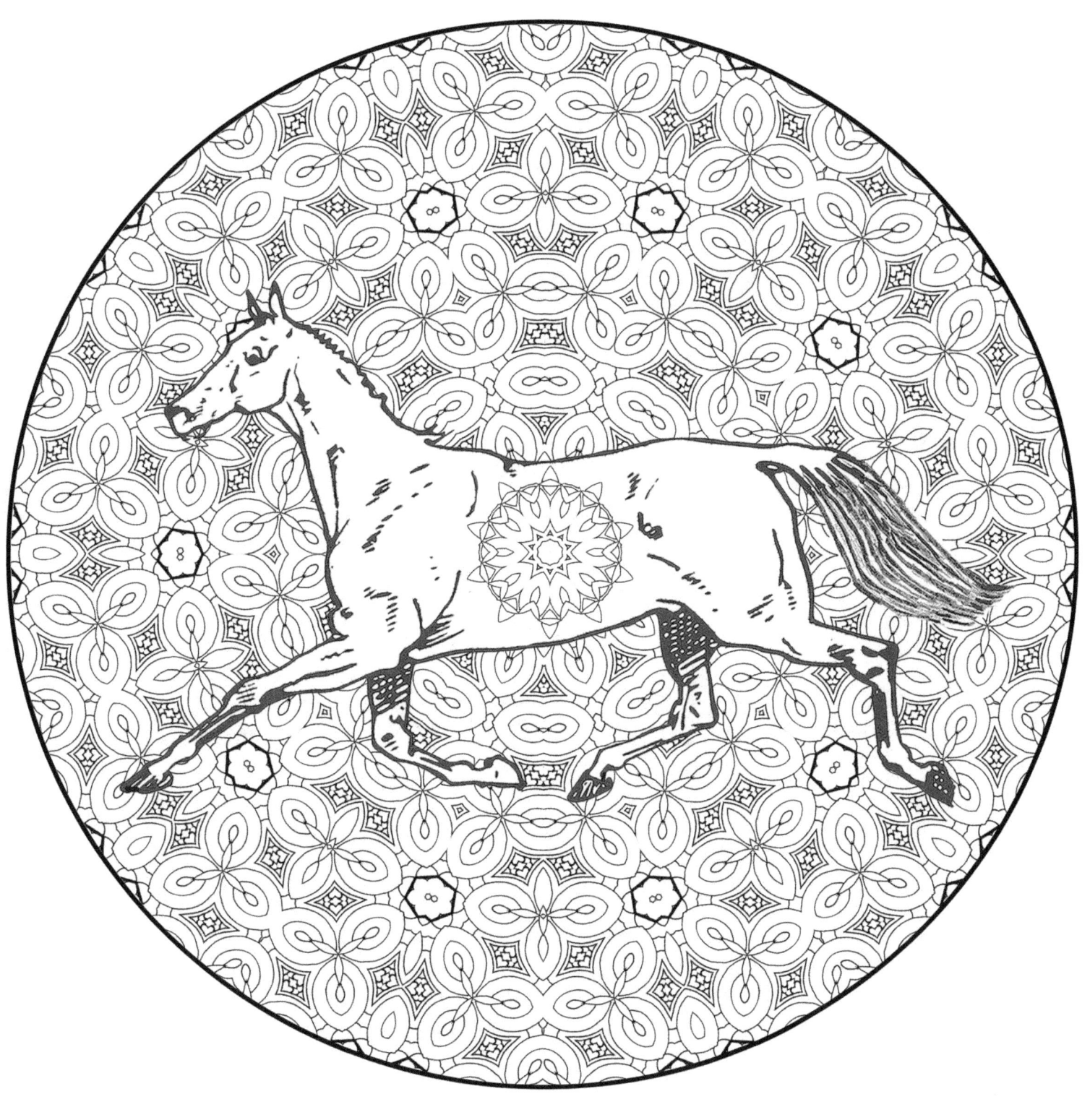
Shasta

This page is intentionally blank.

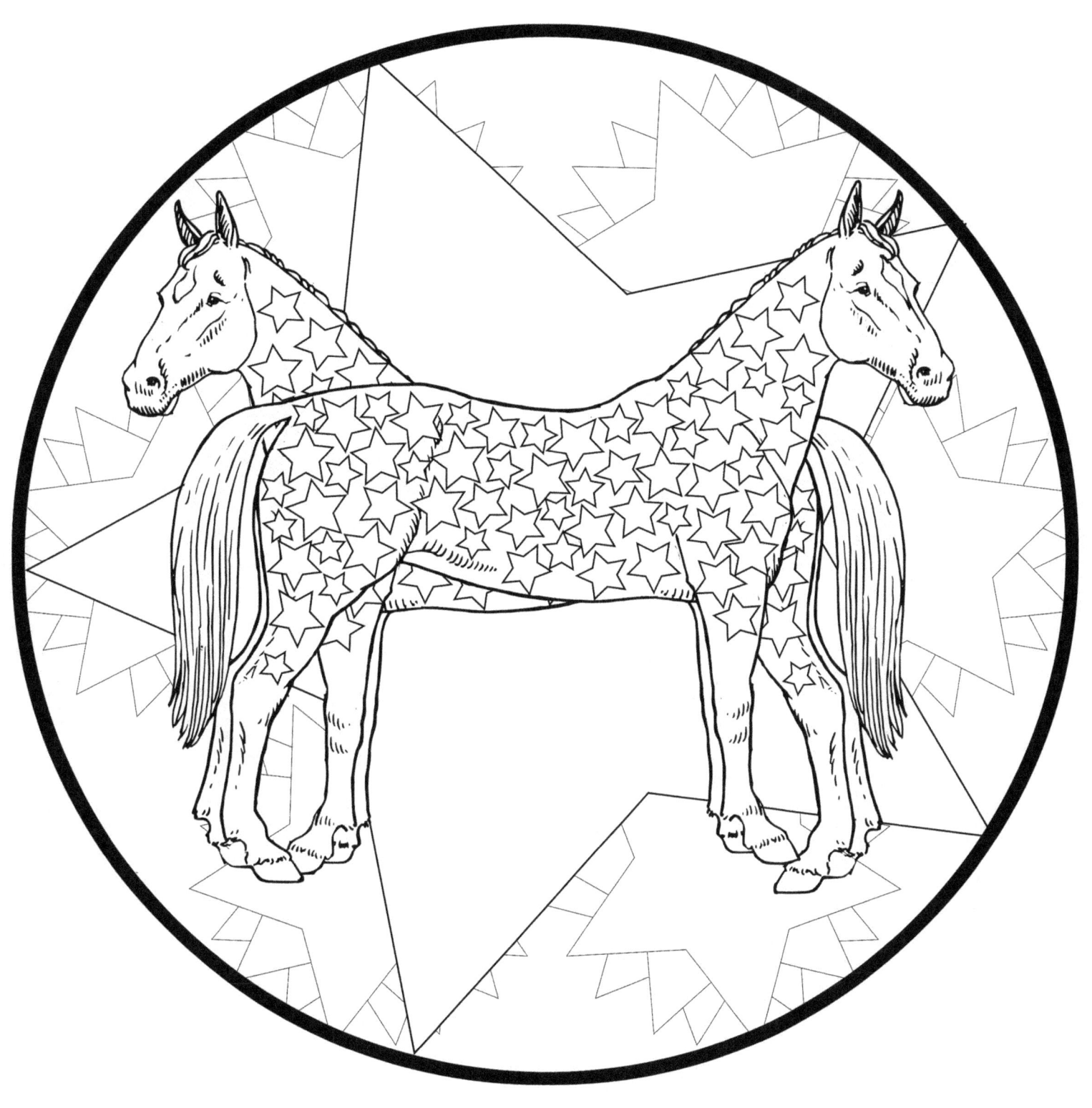

Sid and Sidney Star

This page is intentionally blank.

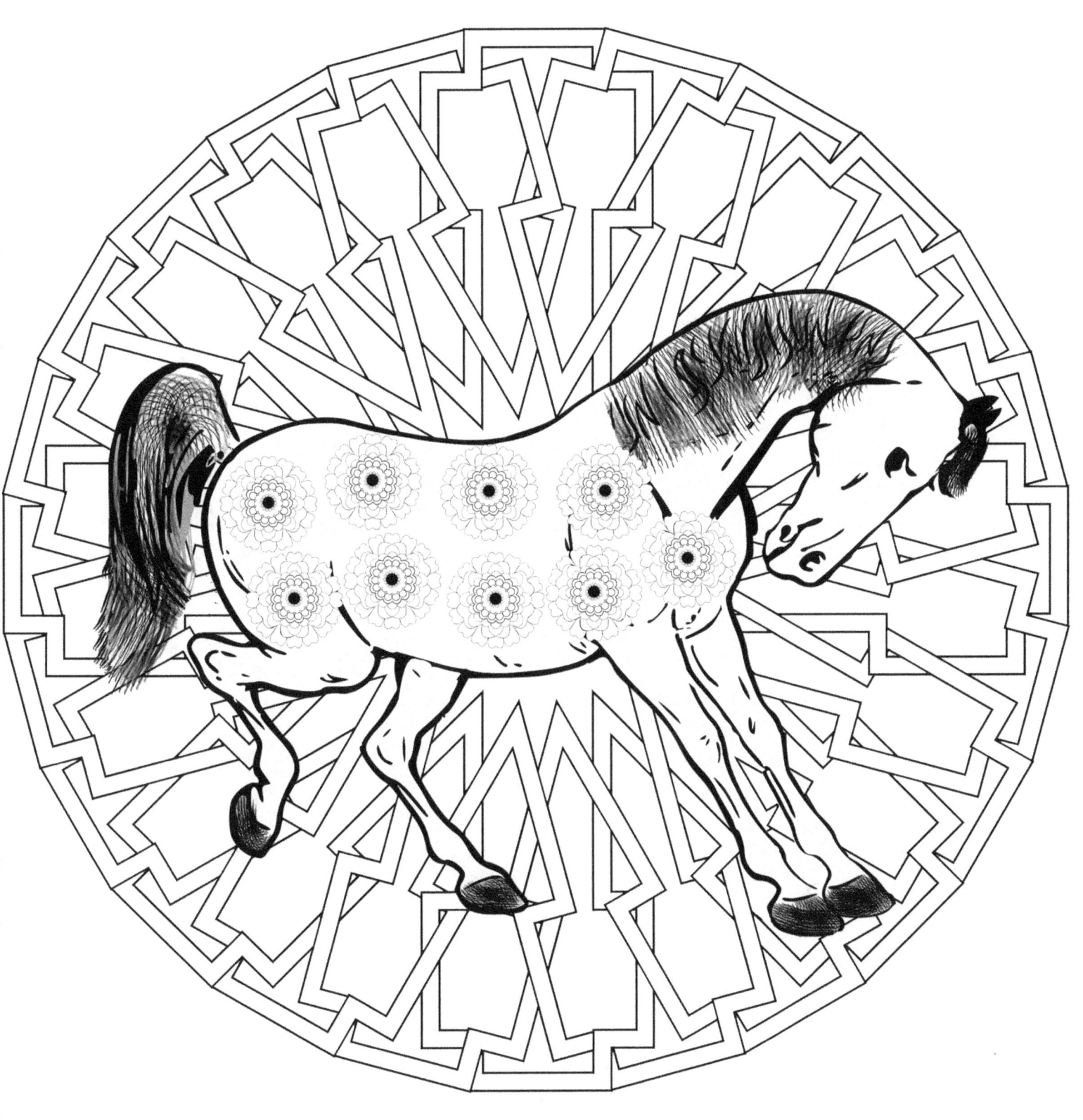

Bonnie the Bowing Horse

This page is intentionally blank.

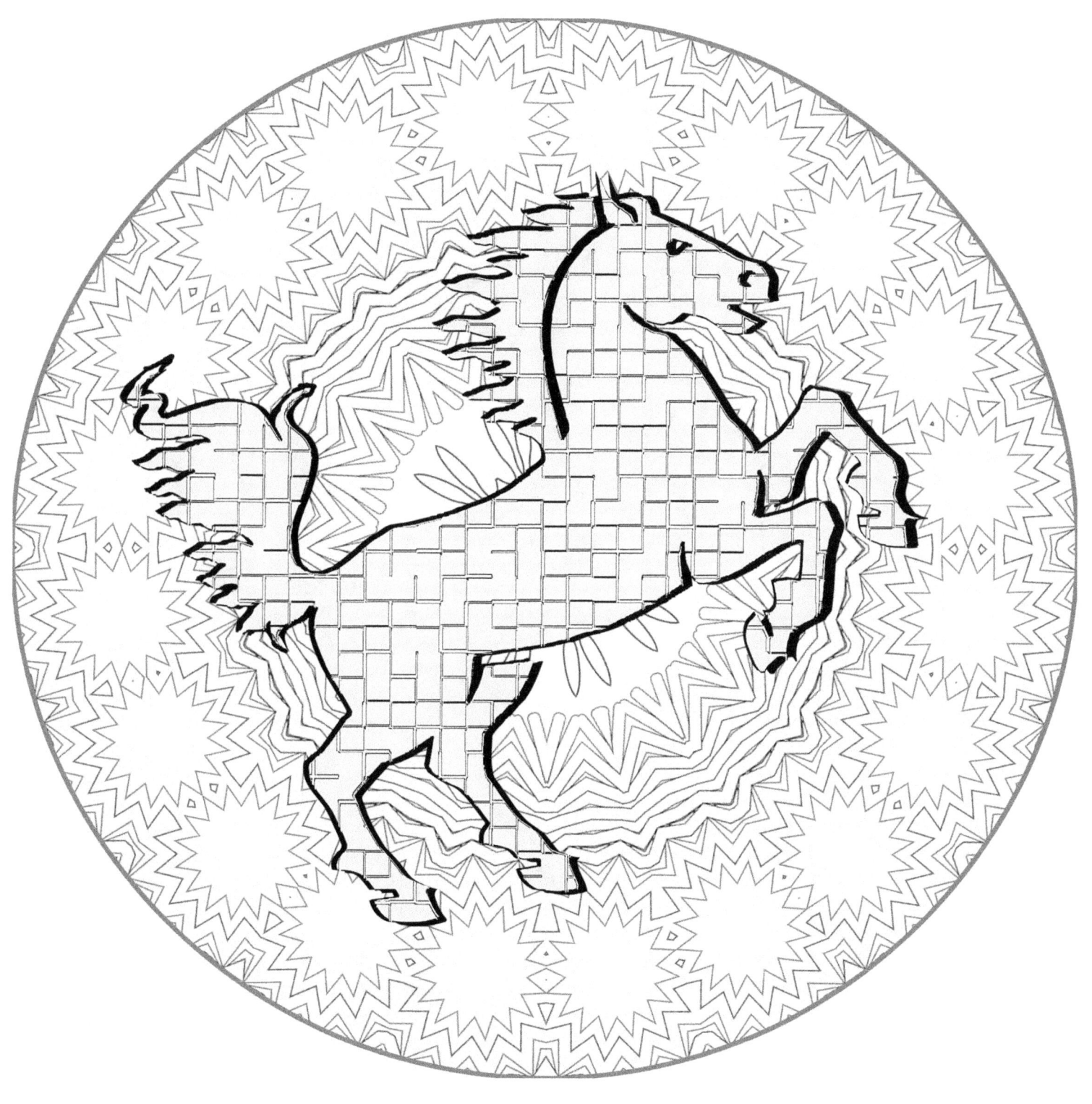

Abstract Bob

This page is intentionally blank.

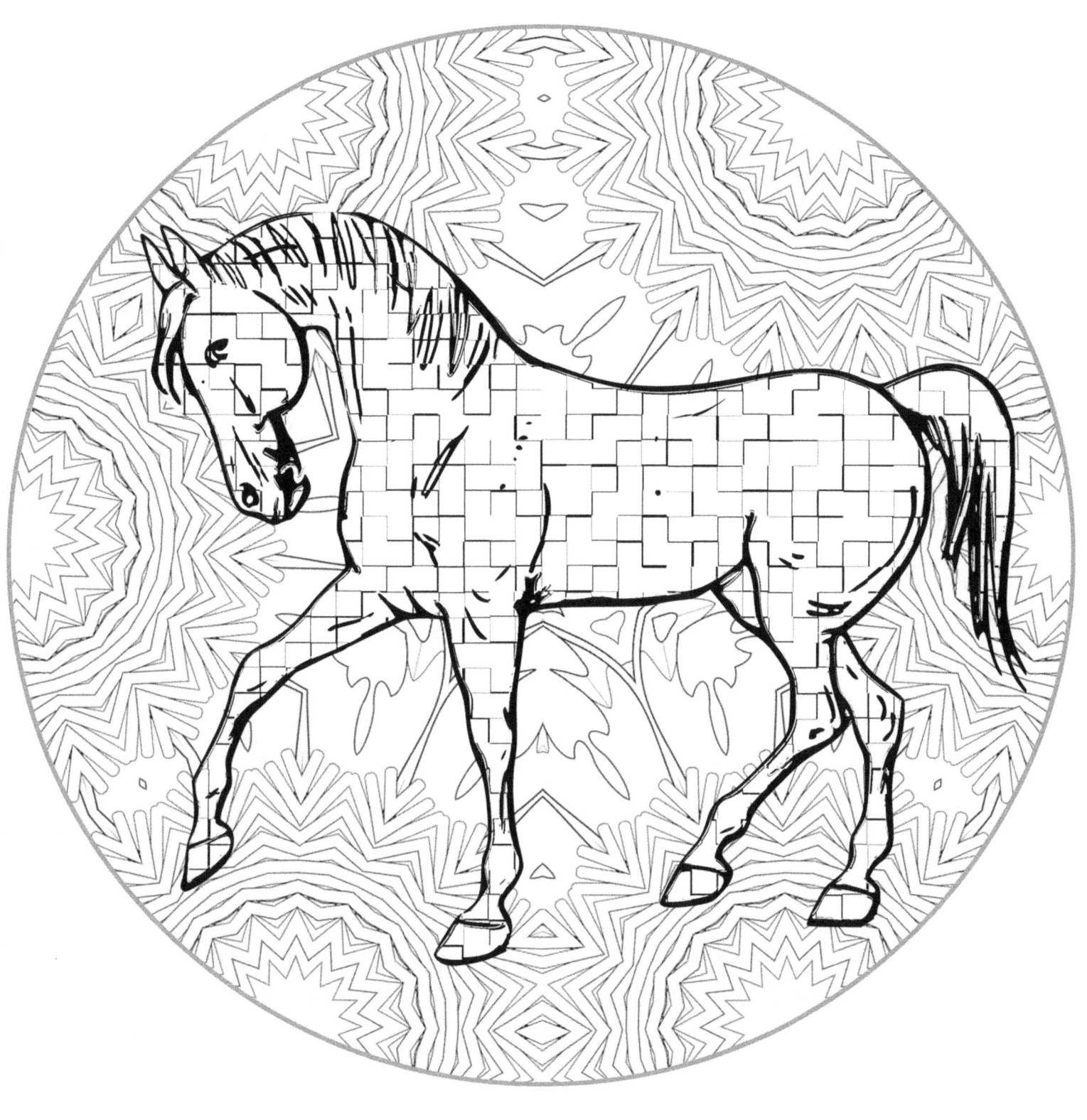

Abstract Slim

This page is intentionally blank.

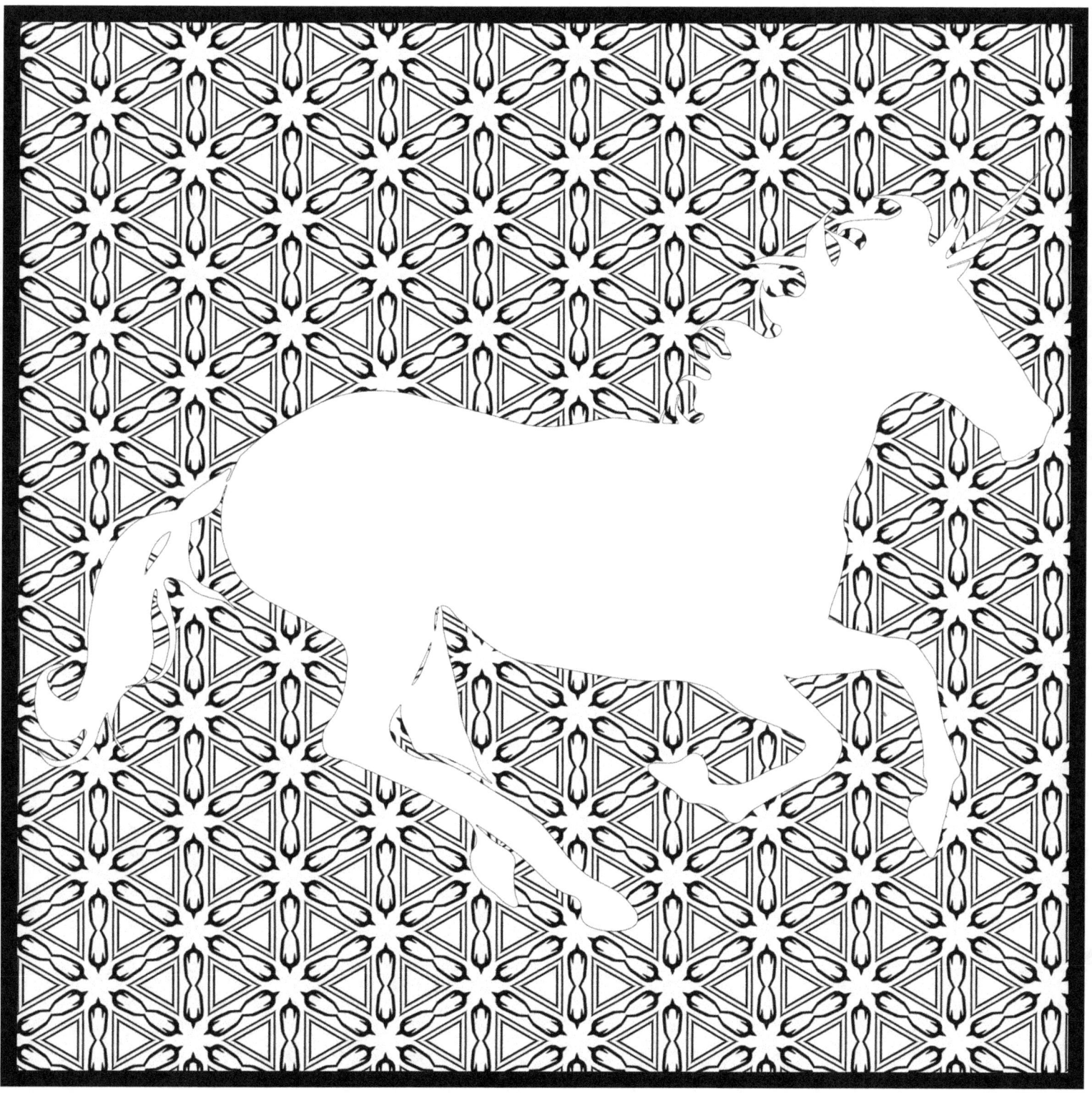

Unicorn

This page is intentionally blank.

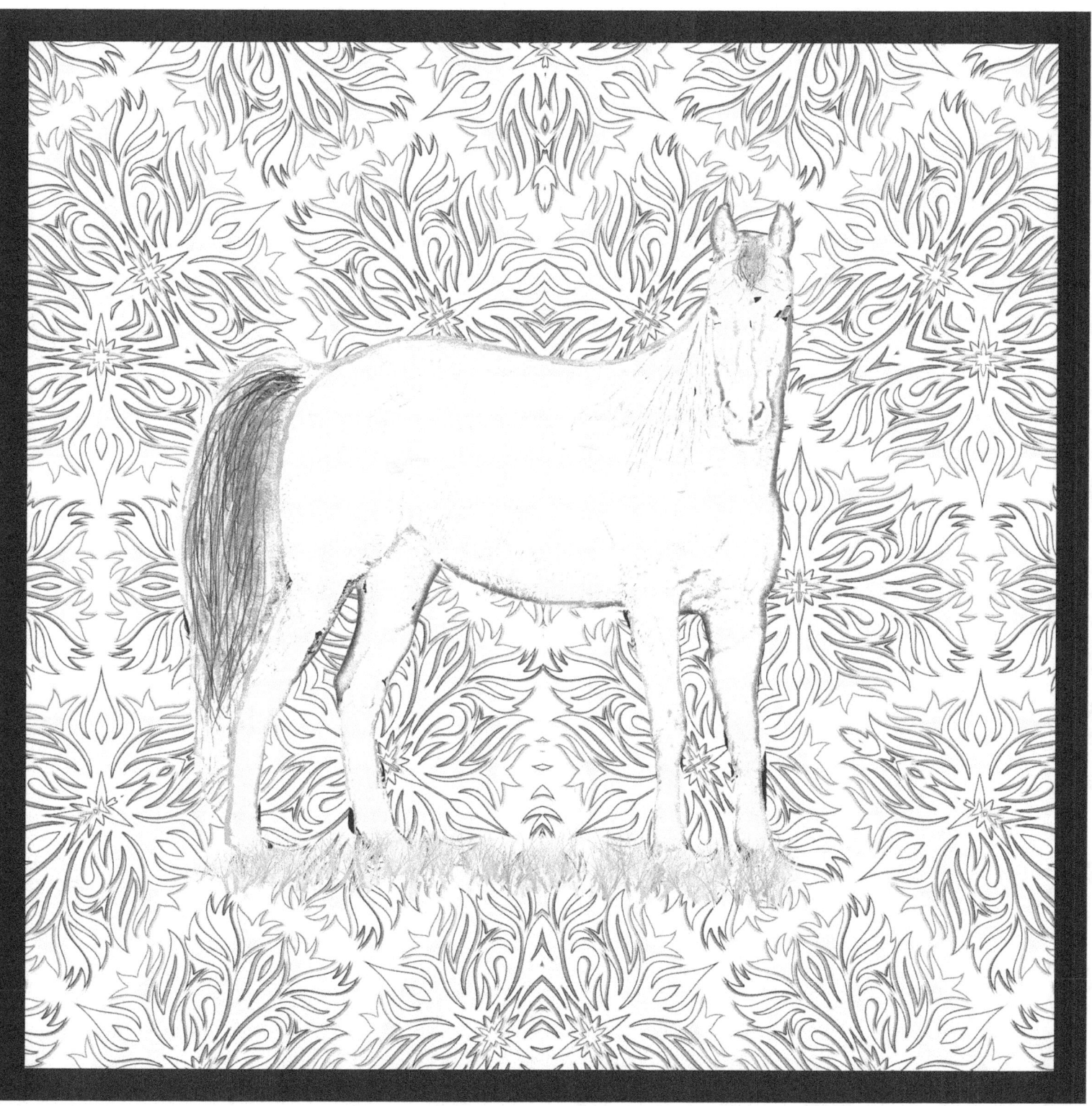

Justine on abstract background

This page is intentionally blank.

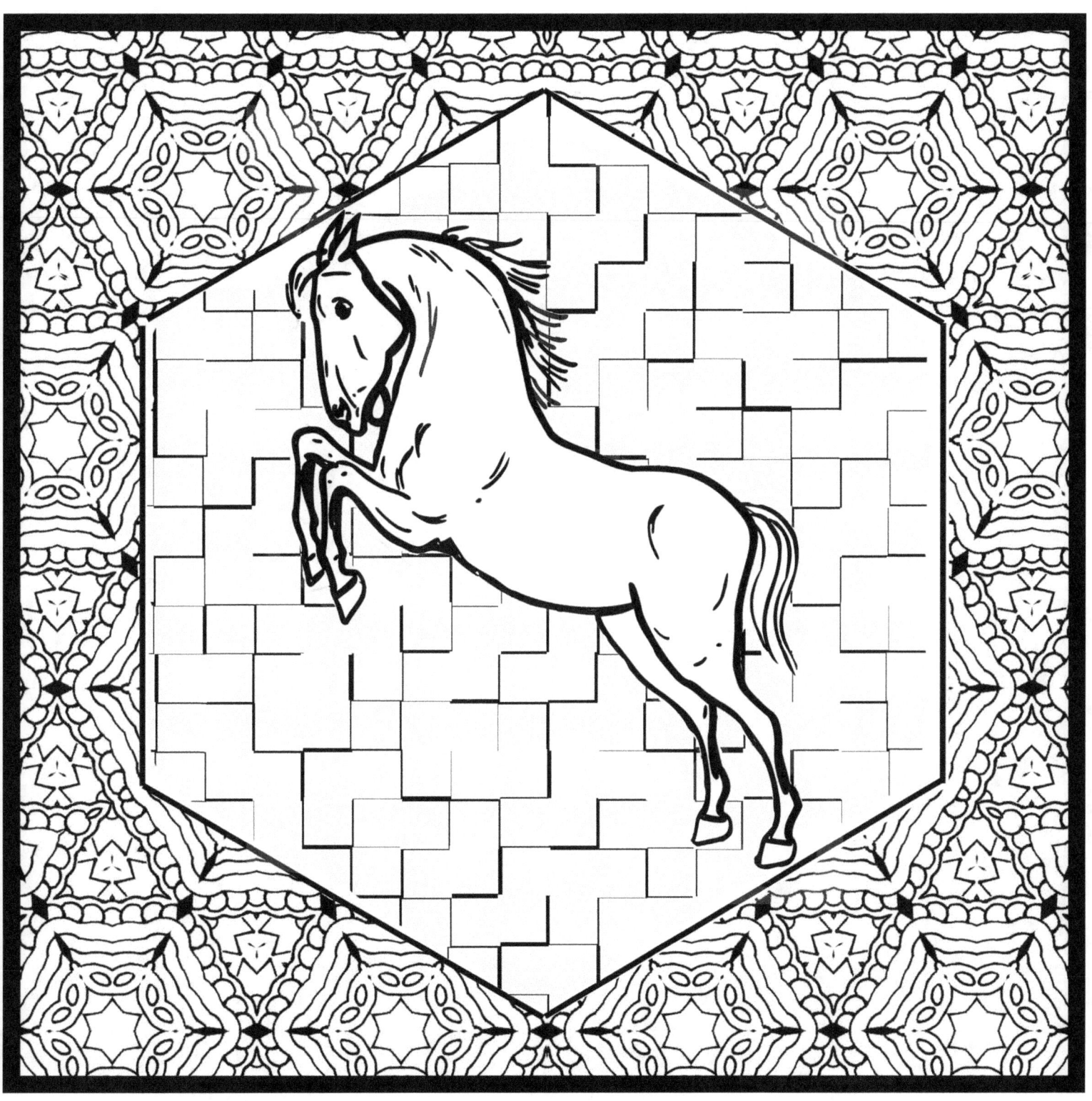

Rudy Abstract Horse

This page is intentionally blank.

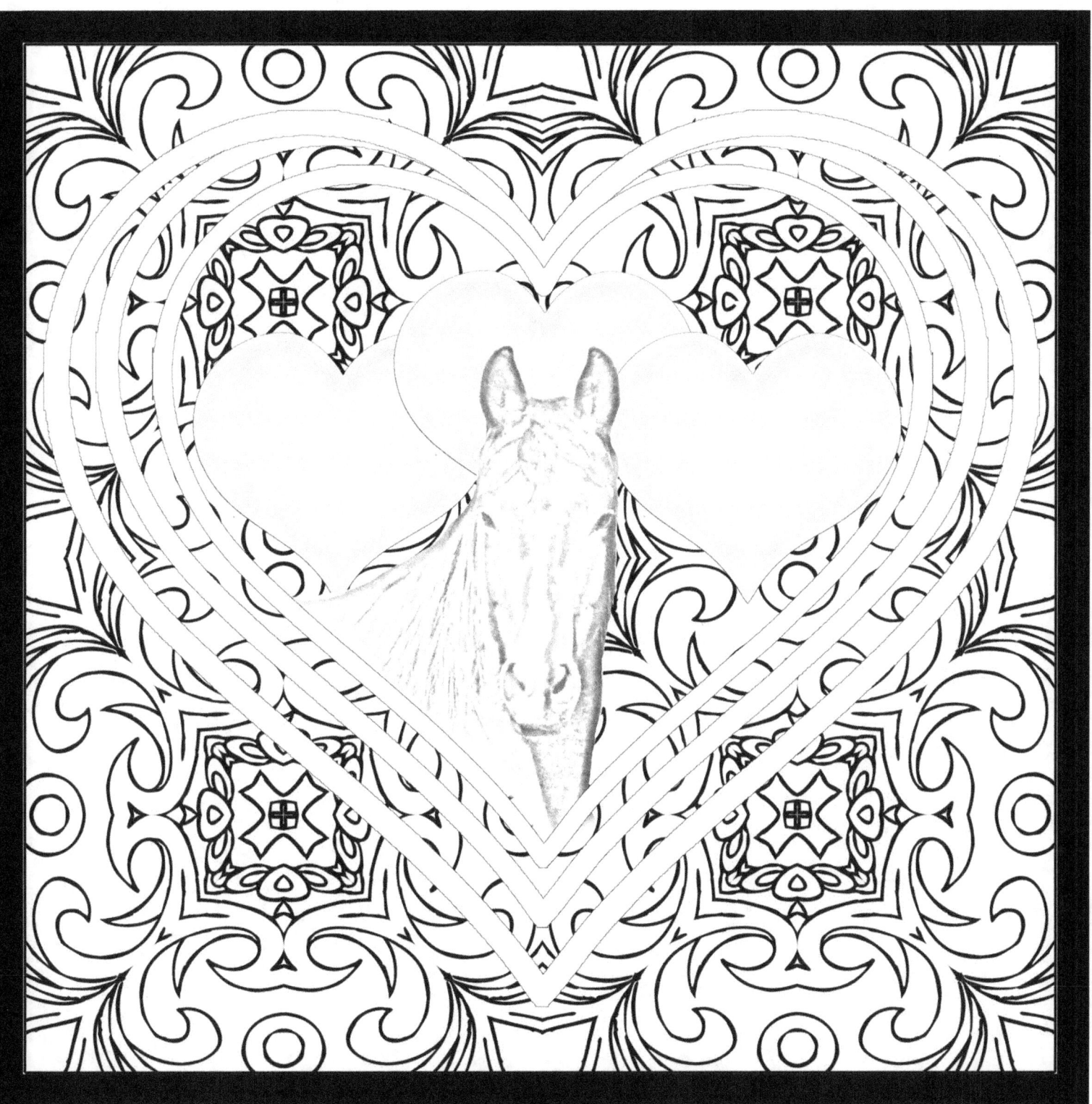

Honey with Six Hearts

This page is intentionally blank.

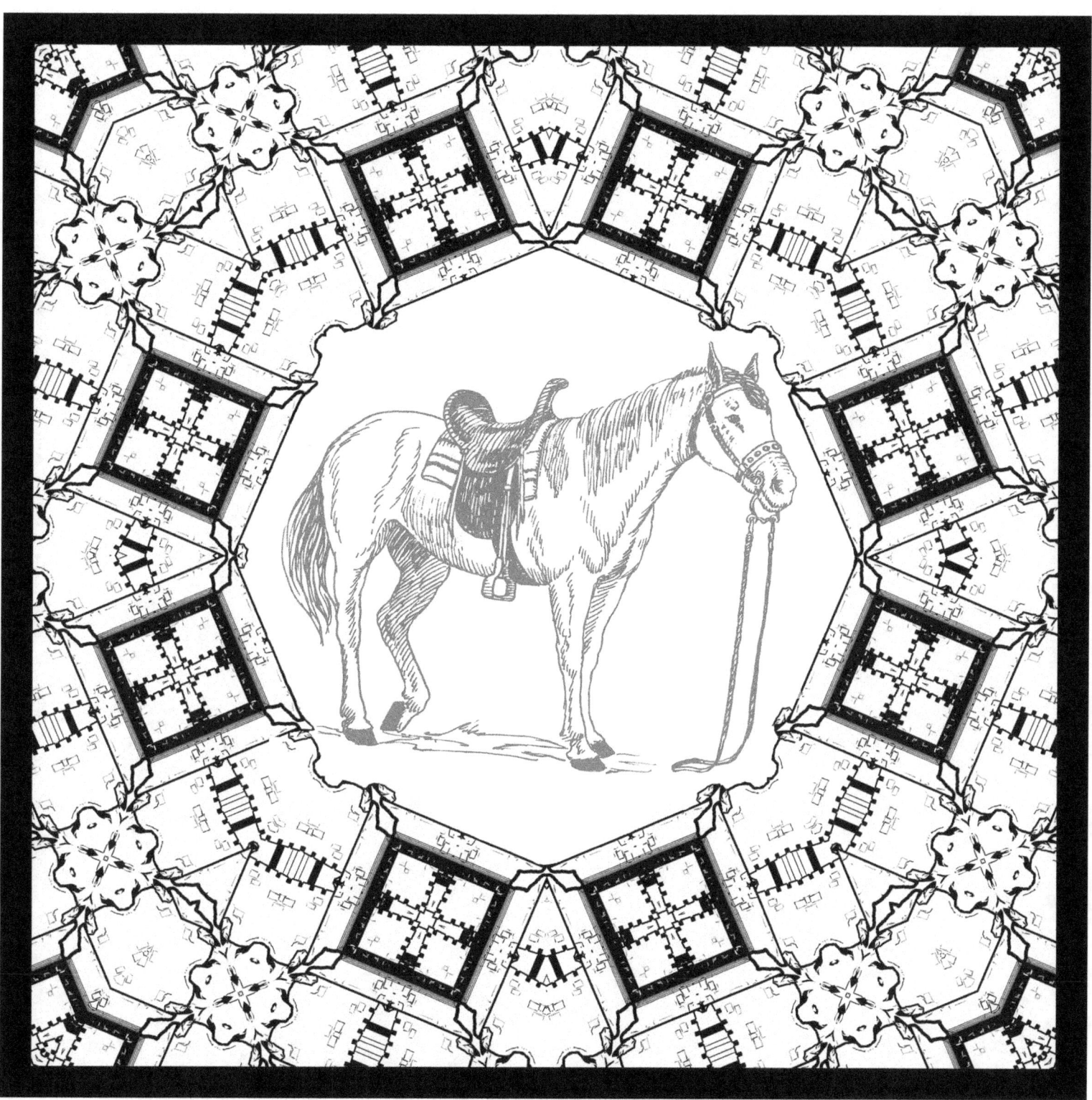

Butch waiting for his cowboy

This page is intentionally blank.

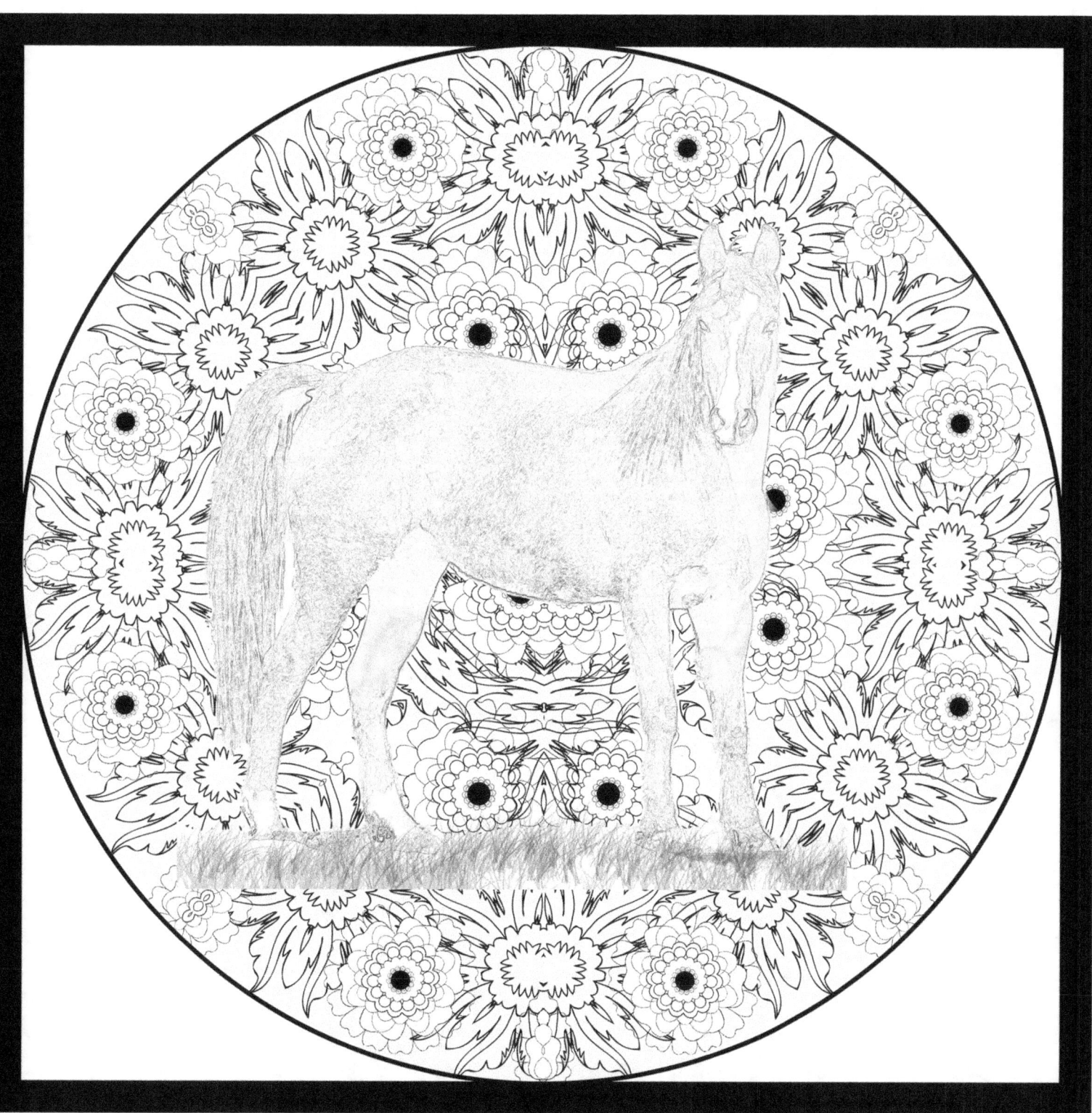

Justine on Flower Background

This page is intentionally blank.

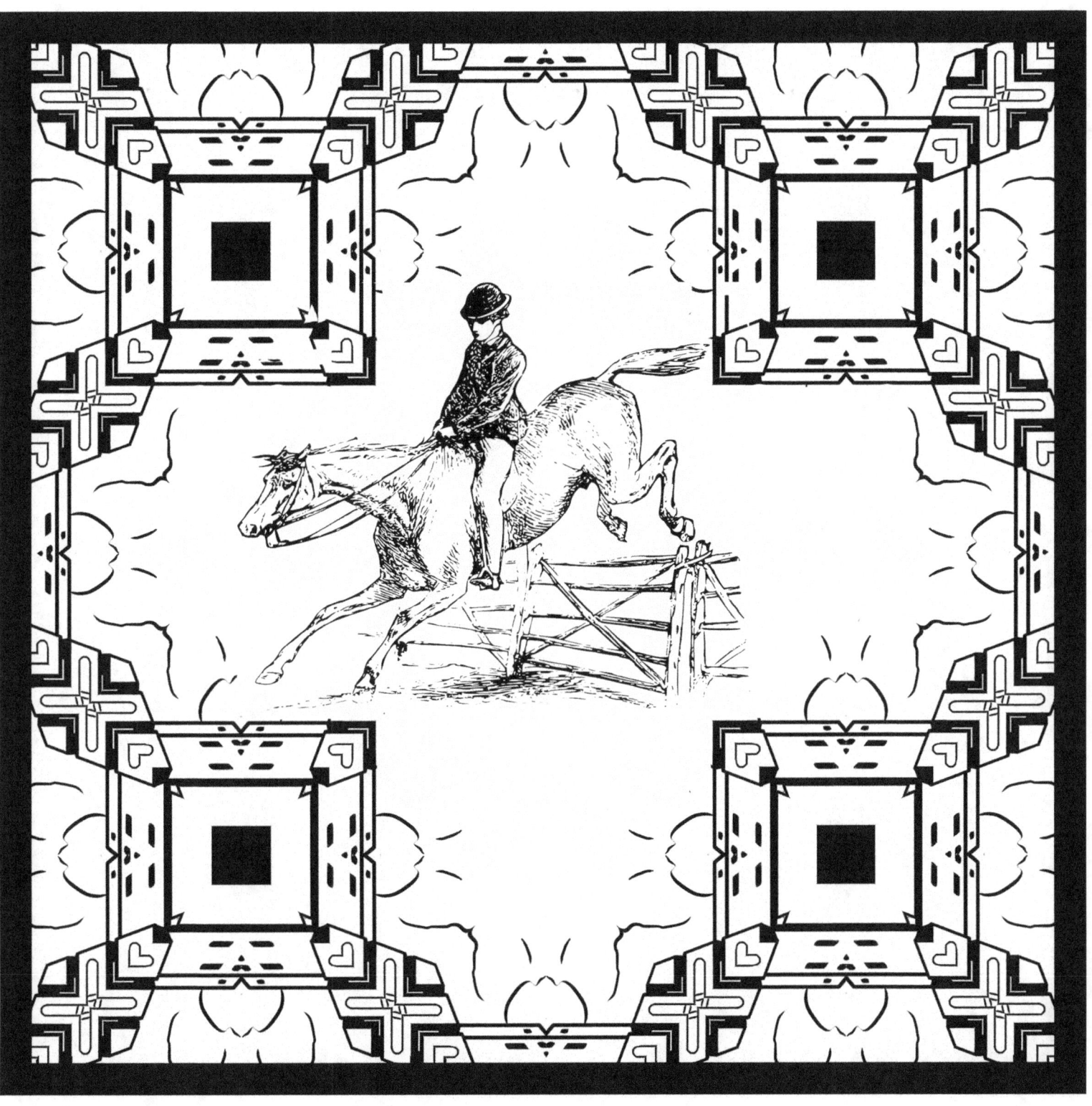

Old English Hunting Photo

This page is intentionally blank.

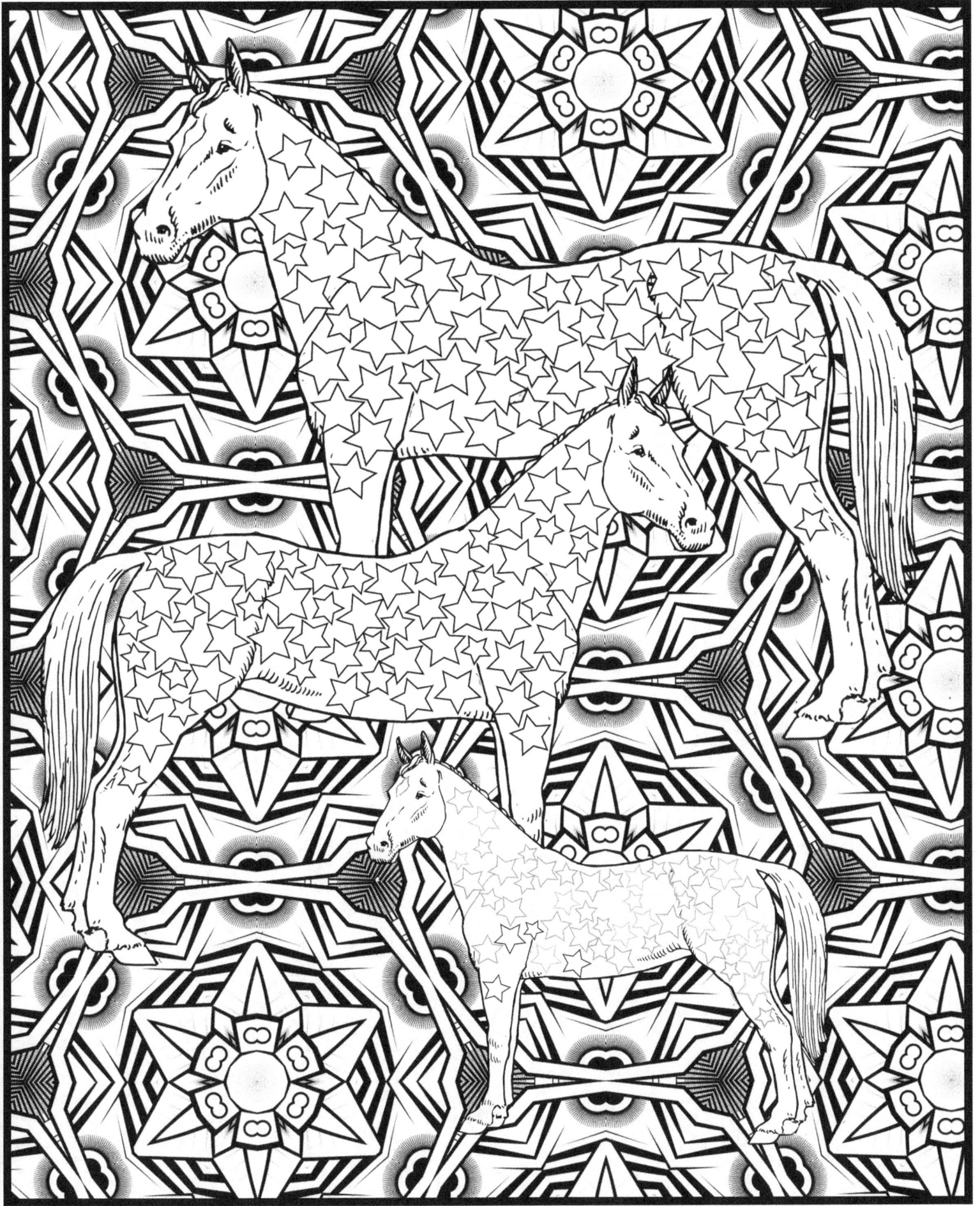

The Star Family

This page is intentionally blank.

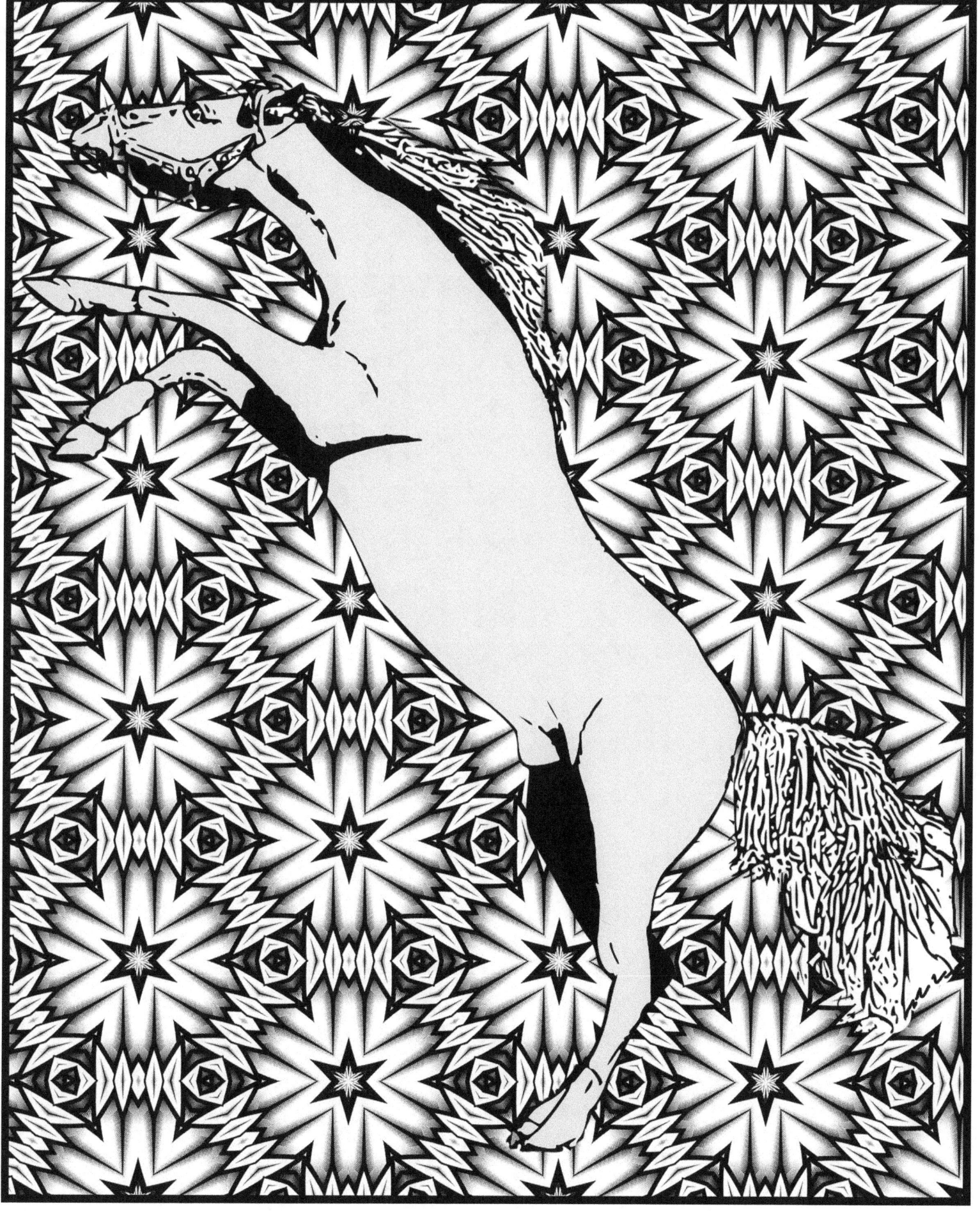

Striker the Stallion

This page is intentionally blank.